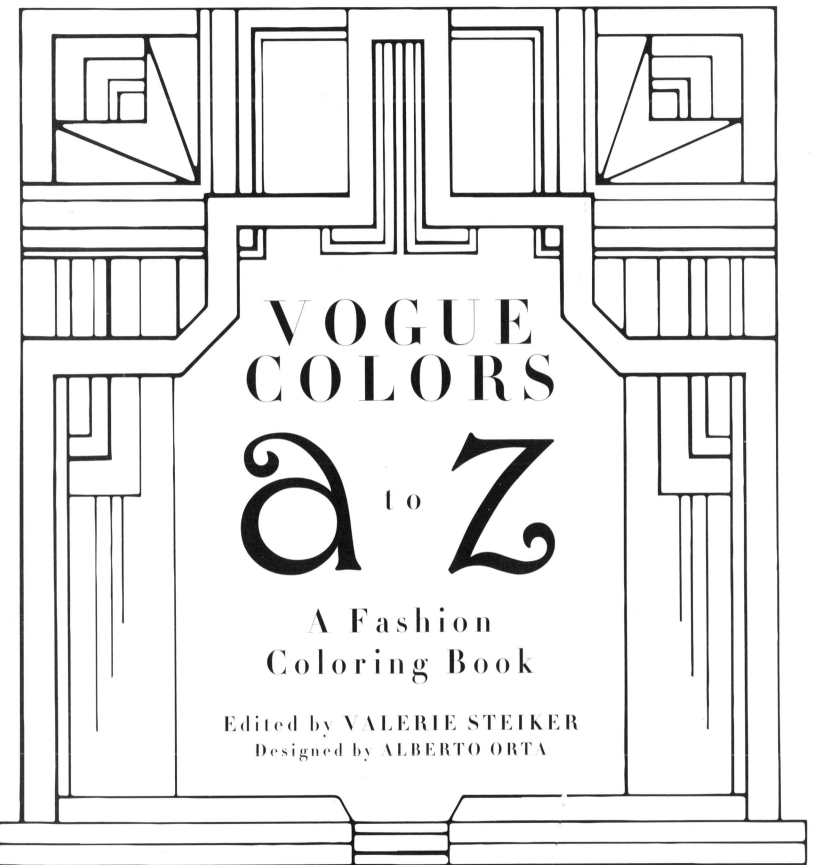

VOGUE COLORS
a to Z

A Fashion Coloring Book

Edited by VALERIE STEIKER
Designed by ALBERTO ORTA

ALFRED A. KNOPF NEW YORK 2016

THIS IS A BORZOI BOOK PUBLISHED BY ALFRED A. KNOPF

Copyright © 2016 by Condé Nast

All rights reserved. Published in the United States by Alfred A. Knopf,
a division of Penguin Random House LLC, New York,
and distributed in Canada by Random House of Canada, a division of
Penguin Random House Canada Limited, Toronto.

www.aaknopf.com

Knopf, Borzoi Books, and the colophon are registered trademarks
of Penguin Random House LLC.

Cover artists: Eduardo Benito, Helen Dryden, Arthur Finley,
Georges Lepape, André Marty, Harriet Meserole, Pierre Mourgue, George Wolfe Plank,
Rita Senger, and E.M.A. Steinmetz

A to Z spot credits: Reinaldo Luza, Jean Oliver, C. Meyer,
Mario Simon, Raymond Bret-Koch, Helen Dryden, Claire Avery, Robert McQuinn,
Farquhar, Pierre Mourgue, Raymond de Lavererie, Georges Lepape, André Marty,
Irma Campbell, Marcel Vertès, Margaret Bull, and Douglas Pollard

Front- and back-flap illustrations by Olga Thomas

Gatefold illustrations, 1912–1932, by Claire Avery,
Robert Kalloch, Douglas Pollard, Porter Woodruff, David,
Main Bocher, and Guillermo Bolin

Deco borders reprinted with permission by Dover Publications, Inc.

ISBN 978-0-451-49382-8

Manufactured in the United States of America

First Edition

This book belongs to

Ali + Nancy Chilton

11 Birds

8 Bobs

6 Flags

6 Boats

In this book you will find...

1 18 Bows

Kitten

2 Dogs

14 Necklaces & Chokers

1 Flower Crown

32 Hats & Headpieces

Feed your dragon
a sugar cube. Steer a gondola down
the Grand Canal. Take a tour
of the alphabet through 26 iconic cover
illustrations from American *Vogue.*
You'll discover fashionable women
outfitted for every occasion, whether clipping
flowers in a garden, floating on a crescent
moon, or sitting on a peacock.
Here are pages and pages of dresses, along
with hats, capes, gloves, ribbons, ruffles,
and ropes of pearls—in richly
detailed Art Deco and Art Nouveau
settings. It's all yours to color in
any fashion you like.

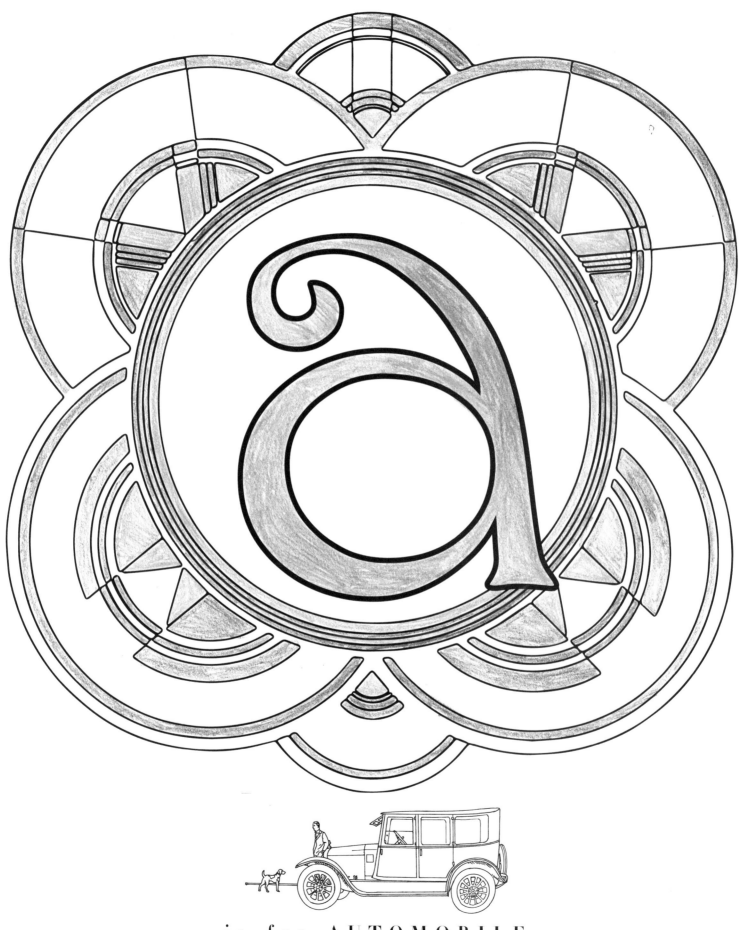

is for AUTOMOBILE

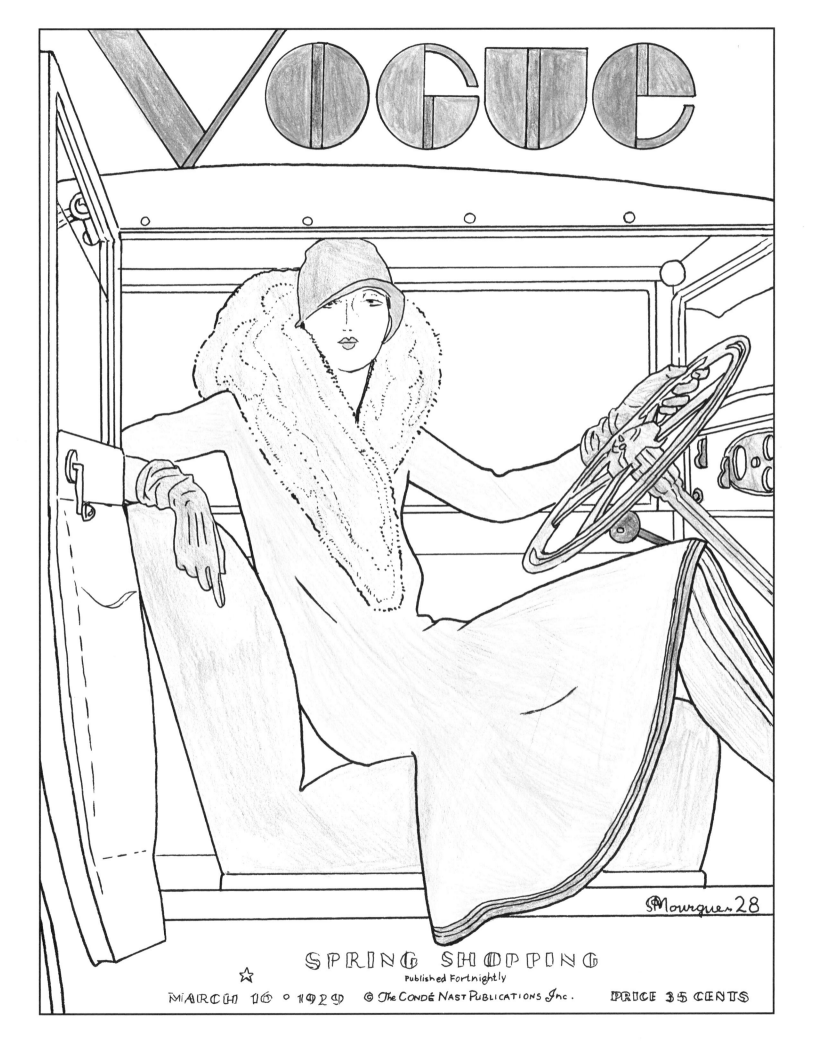

is for BOA

Spring Pattern number of Vogue

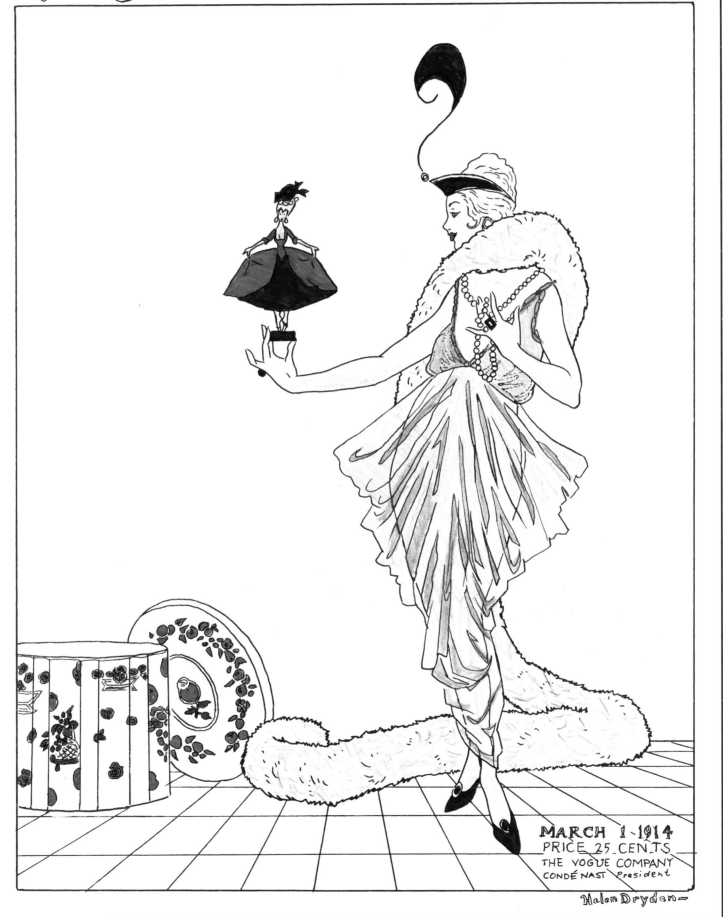

MARCH 1·1914
PRICE 25 CENTS
THE VOGUE COMPANY
CONDÉ NAST President

Helen Dryden

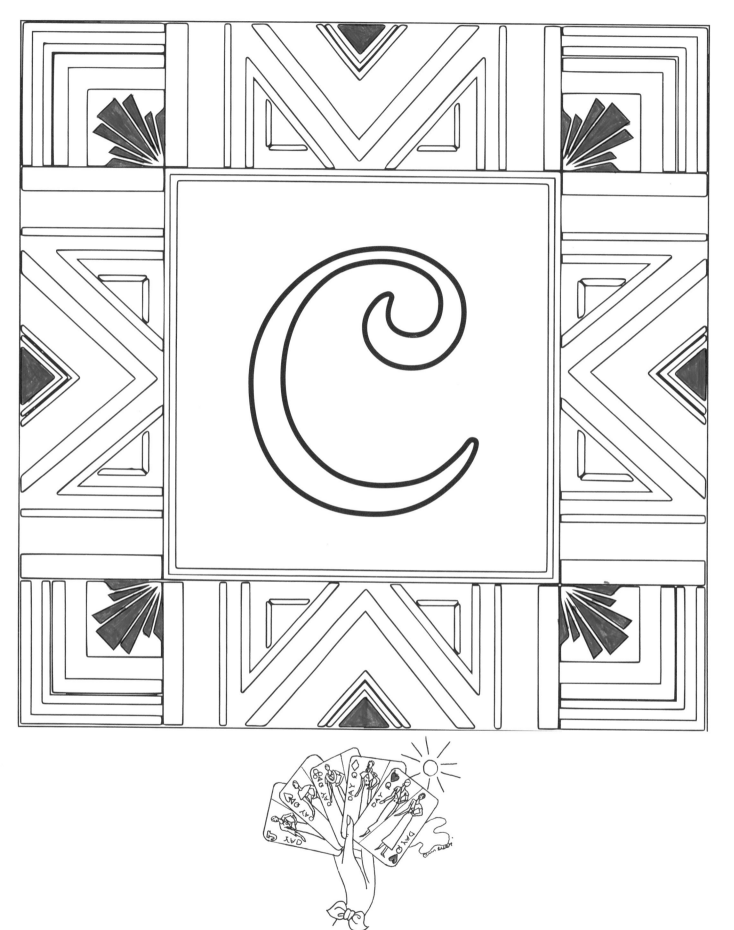

is for CARDS

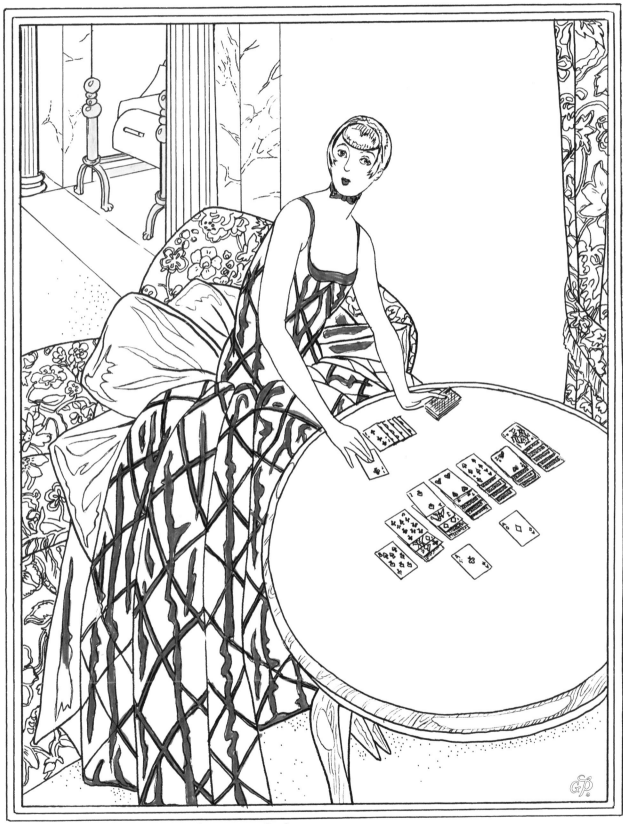

·VOGUE·

Travel Features in this Number

The Condé Nast Publications Inc.

June 13·1925

Price 35 Cents

is for DRAGON

VOGUE

Spring Fabrics and
Original Vogue Designs

February First 1923
Price Thirty-five Cents

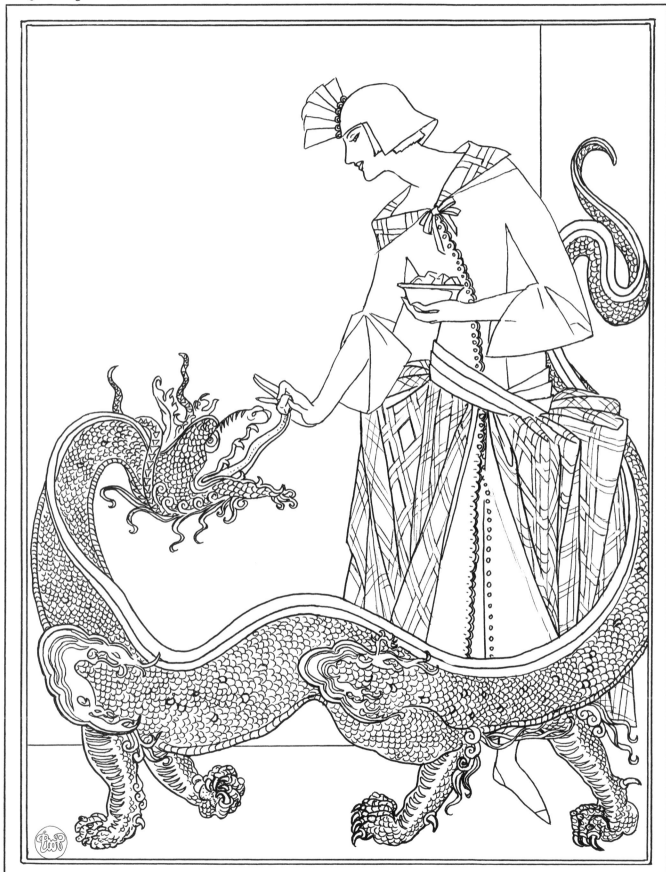

The Vogue Company
CONDÉ NAST Publisher

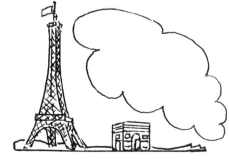

is for EIFFEL TOWER

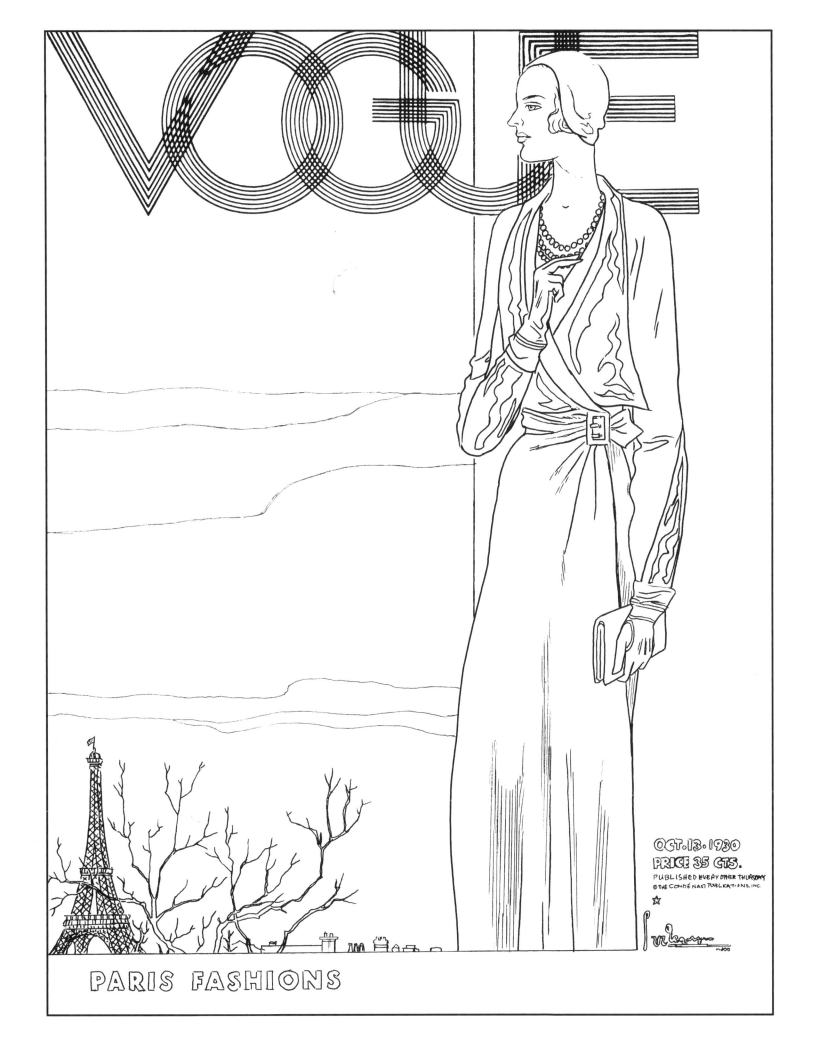

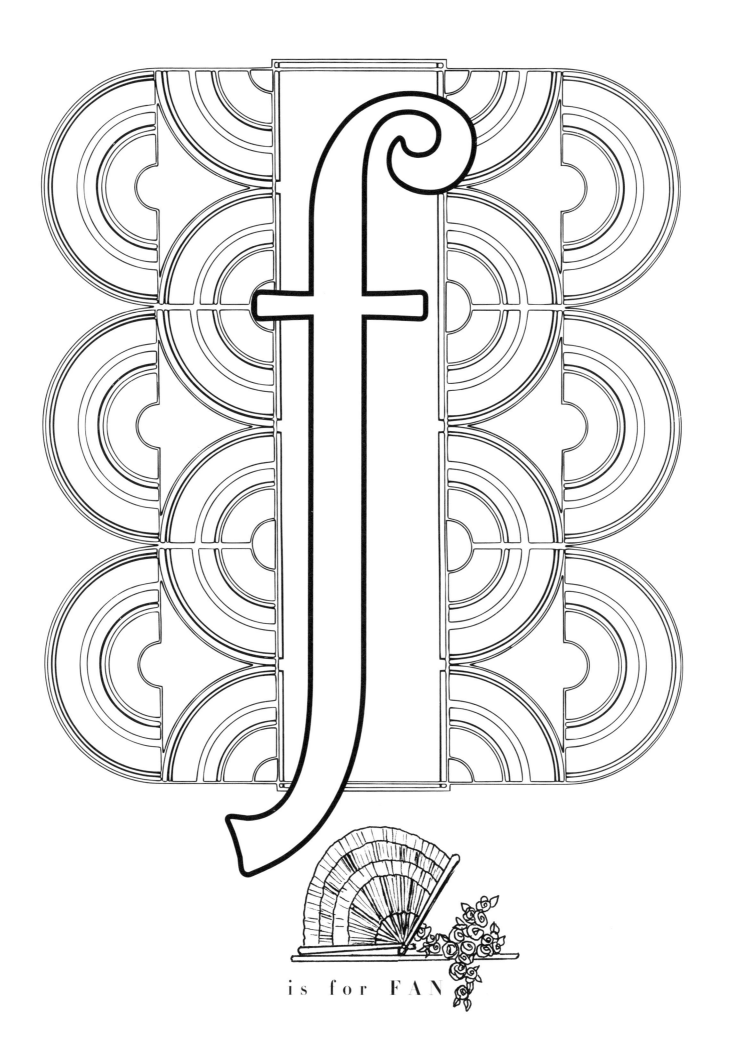

is for FAN

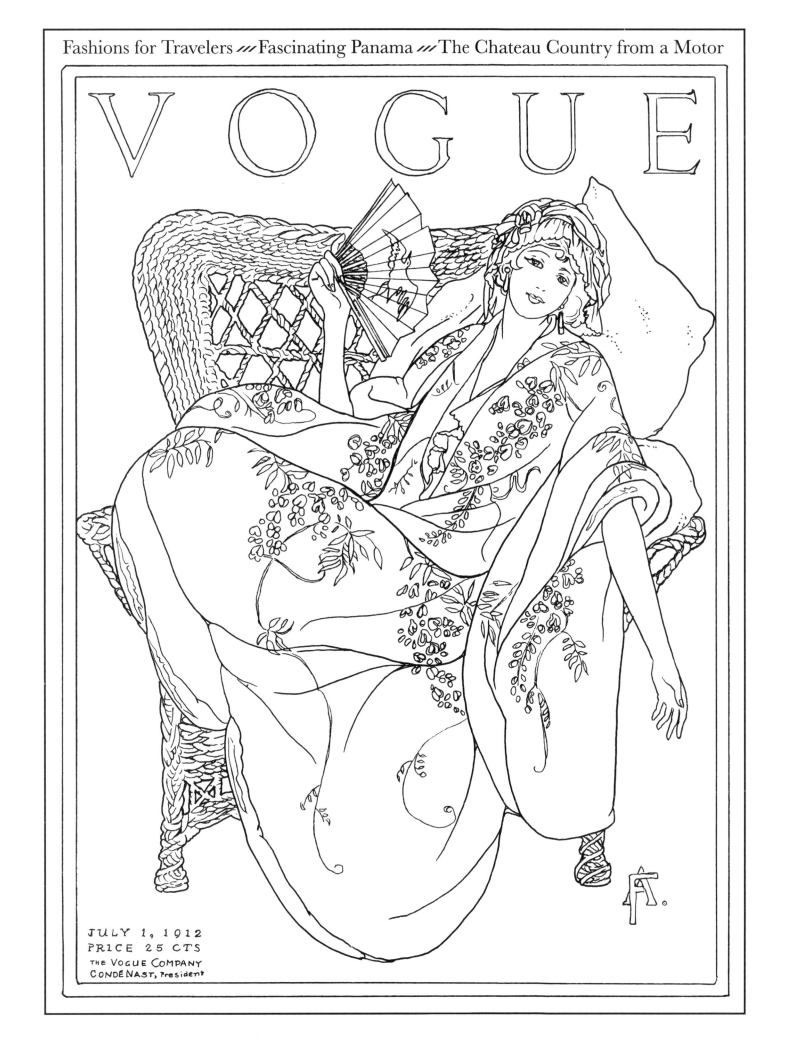

Fashions for Travelers ⁄⁄⁄ Fascinating Panama ⁄⁄⁄ The Chateau Country from a Motor

VOGUE

JULY 1, 1912
PRICE 25 CTS
THE VOGUE COMPANY
CONDÉ NAST, President

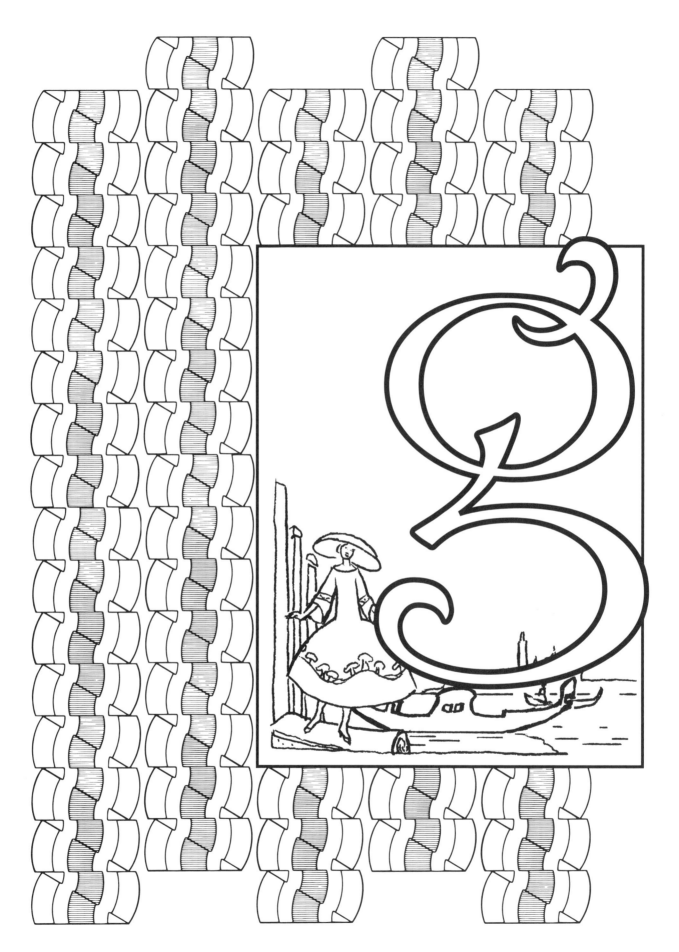

is for GONDOLA

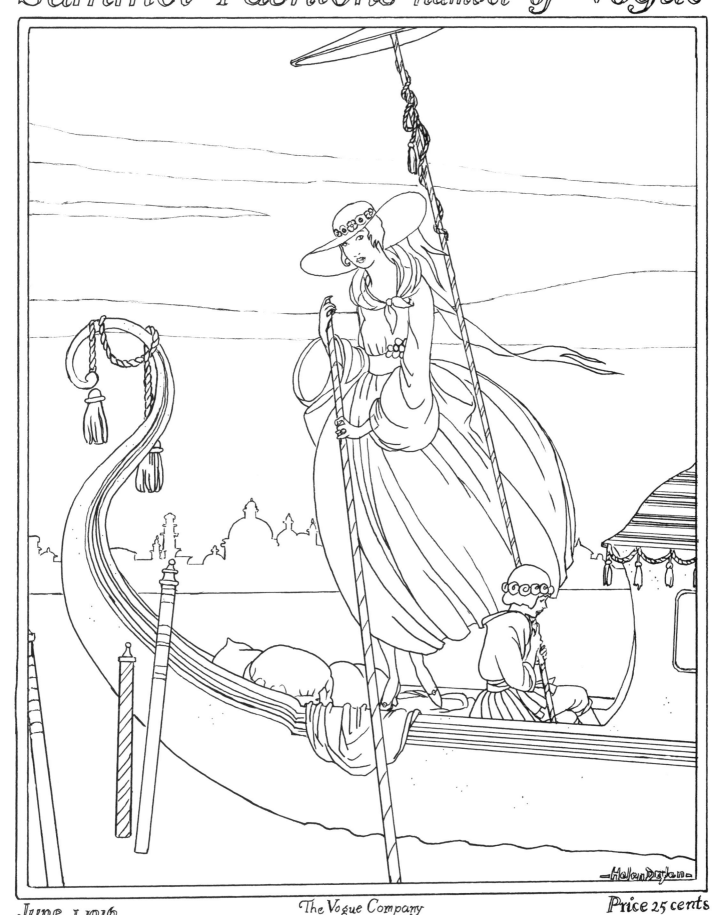

June 1 1916

The Vogue Company
CONDÉ NAST Publisher

Price 25 cents

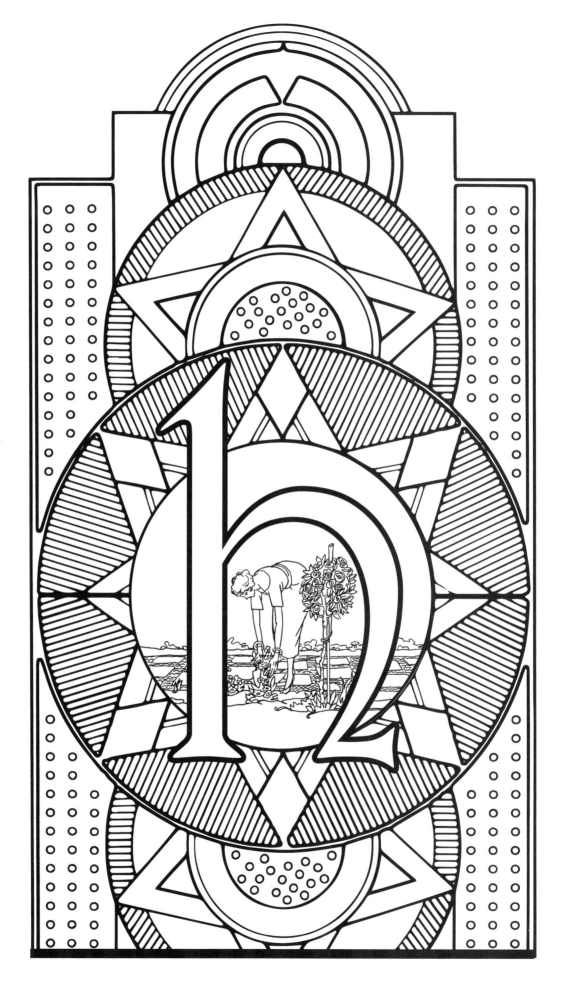

is for HORTICULTURE

Spring Fashions
Number

VOGUE

March 15 · 1918
Price 25 Cents

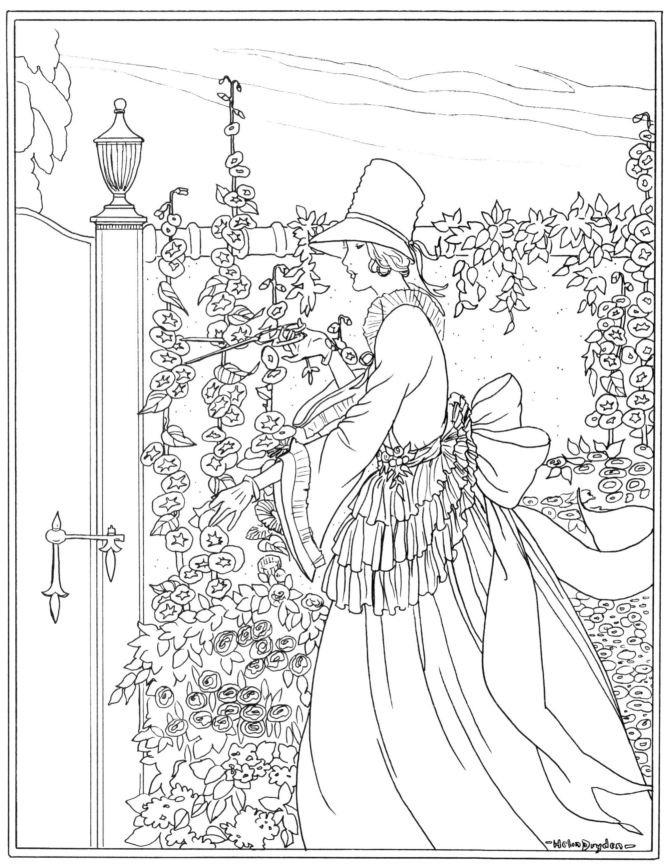

CONDÉ NAST. Publisher

i s f o r I S L A N D

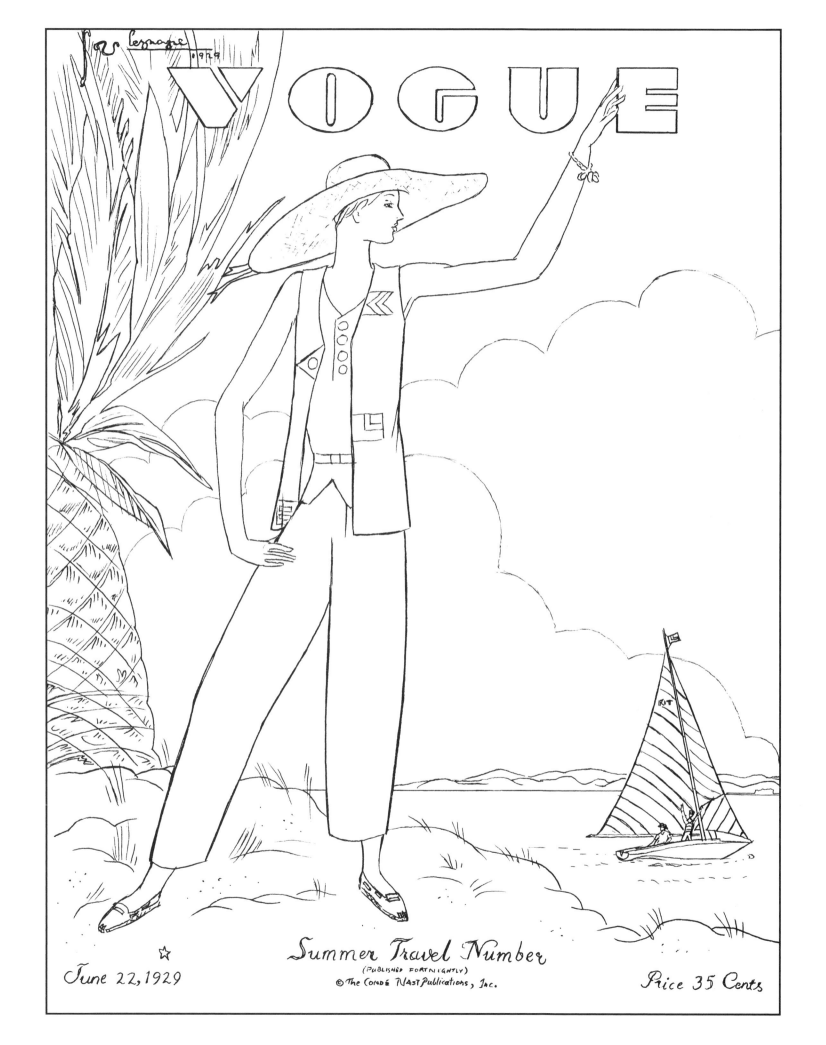

VOGUE

Summer Travel Number
(PUBLISHED FORTNIGHTLY)
© The Condé Nast Publications, Inc.

June 22, 1929

Price 35 Cents

is for JEWELRY

·VOGUE·

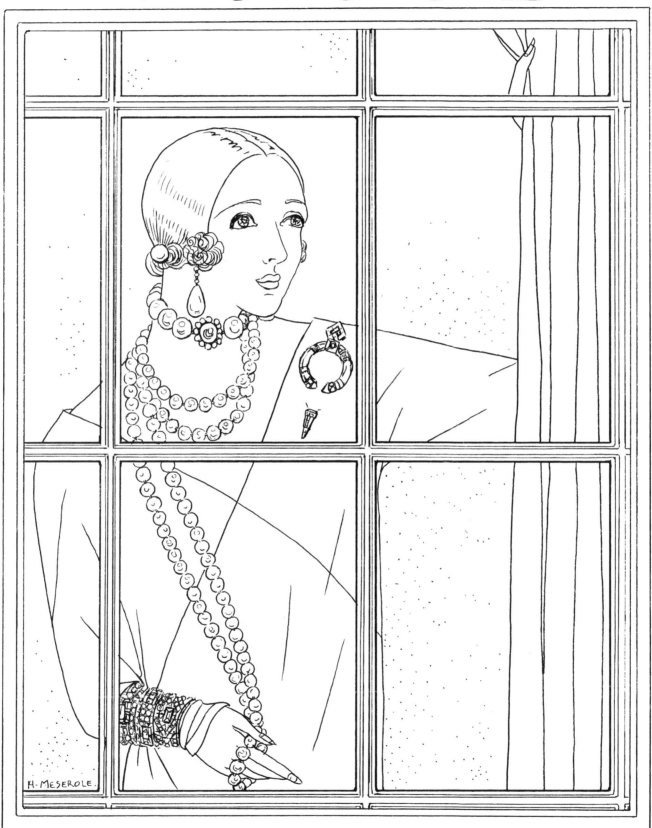

Early Paris Openings

October 1·1924

The Condé Nast Publications, Inc.

Price 35 Cents

is for KID GLOVE

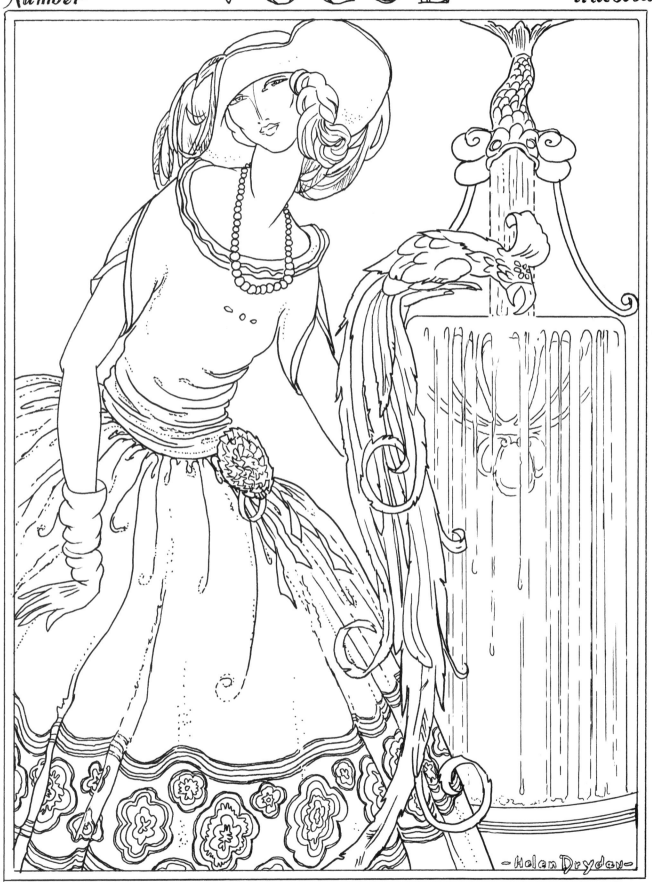

Summer Fashions Number

VOGUE

June First · 1921
Price 35 cts.

-Helen Dryden-

The Vogue Company
CONDÉ NAST Publisher

is for LIPSTICK

LINGERIE
NUMBER

VOGUE

JANUARY 1, 1915
PRICE 25 CENTS

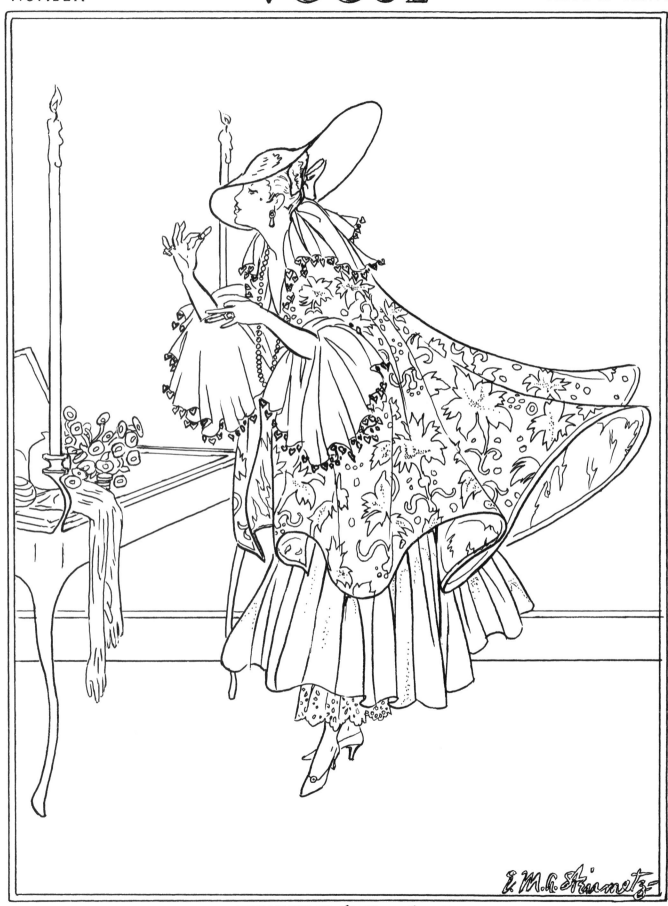

THE VOGUE COMPANY, CONDÉ NAST
Publisher

is for MOON

VOGUE

Vanity Number

Nov 15-1917
Price 25 Cts

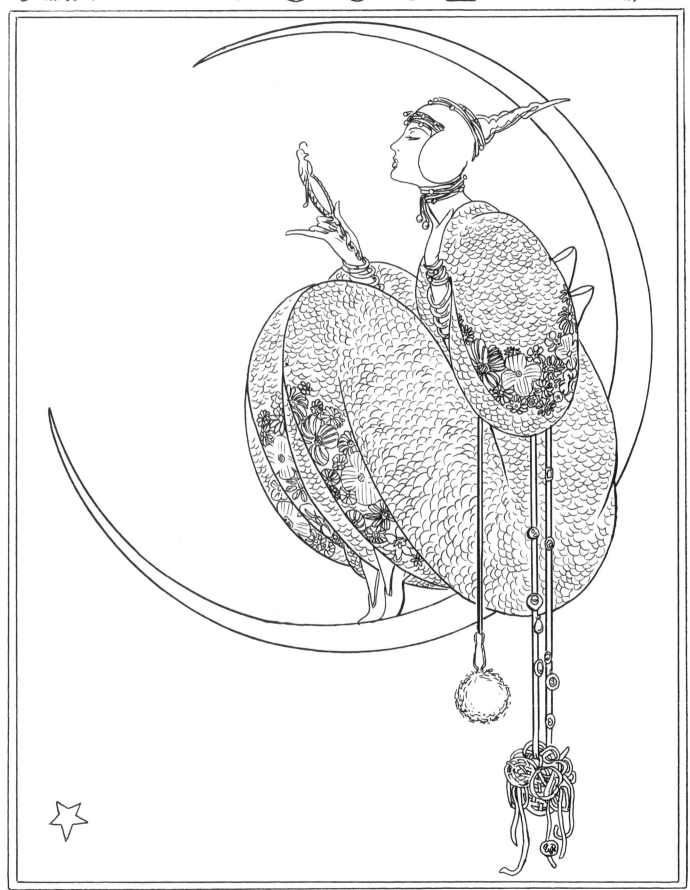

The Vogue Company
CONDÉ NAST. Publisher

is for NET

Hot Weather Fashions Number

VOGUE

July 1 · 1921
Price 35 Cents

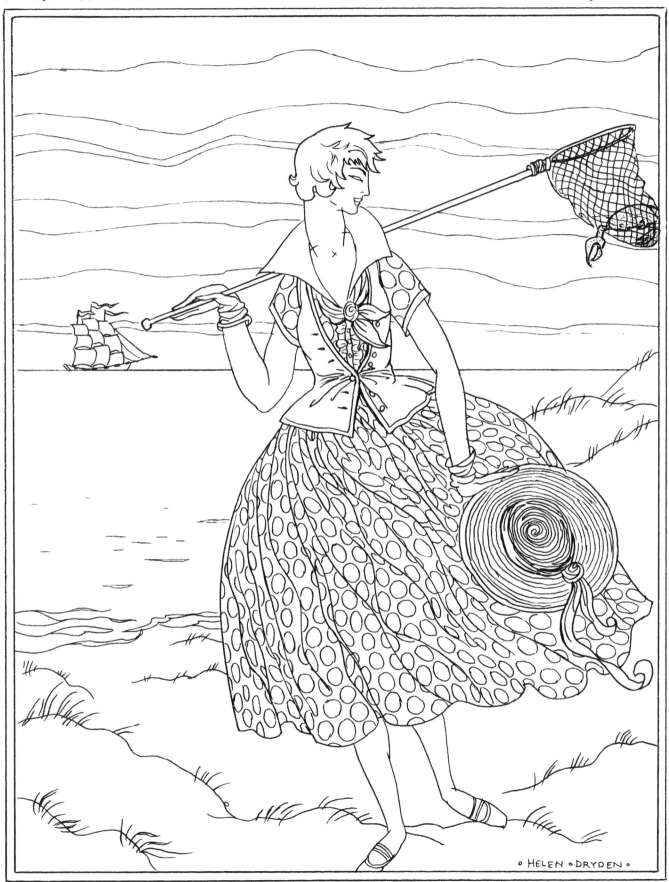

· HELEN · DRYDEN ·

The Vogue Company
CONDÉ NAST Publisher

is for OVAL MIRROR

Spring Millinery
Number

VOGUE

NOTICE TO READER—When you finish reading this magazine place a 1c. stamp on this notice, hand same to any postal employee, and it will be placed in the hands of our soldiers or sailors at the front. No wrapping, no address.—A. S. Burleson, Postmaster-General.

February 15, 1918

CONDÉ NAST *Publisher*

Price 25 Cents

is for PEACOCK

Paris Openings
Number

VOGUE

April 1 1918
Price 25 Cents

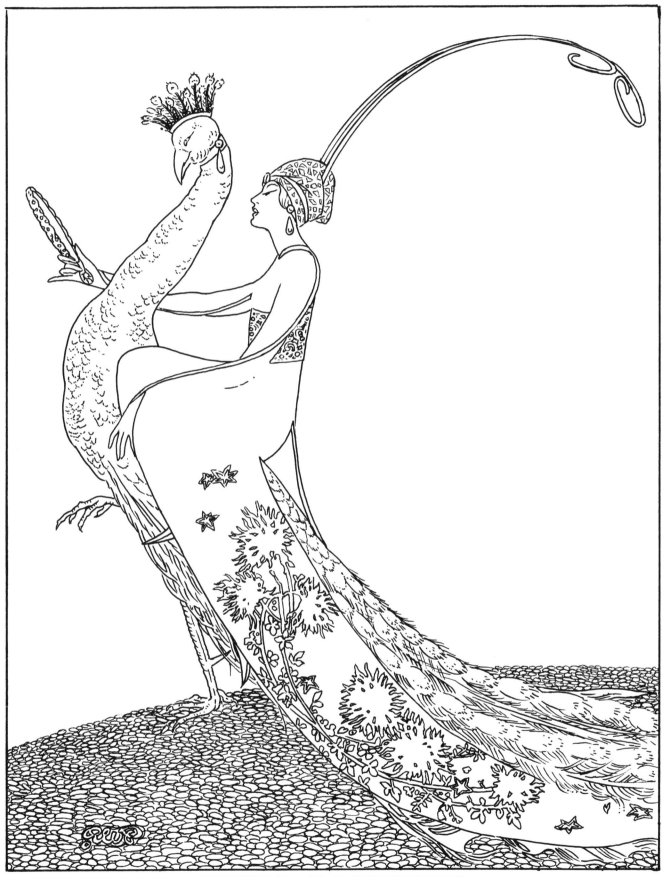

CONDÉ NAST. Publisher

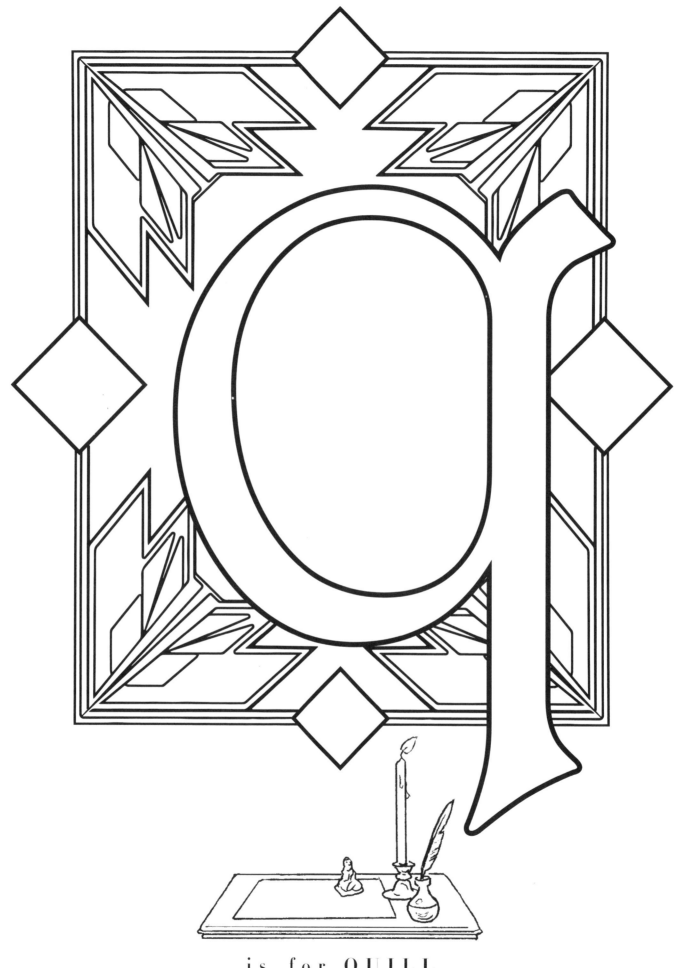

is for QUILL

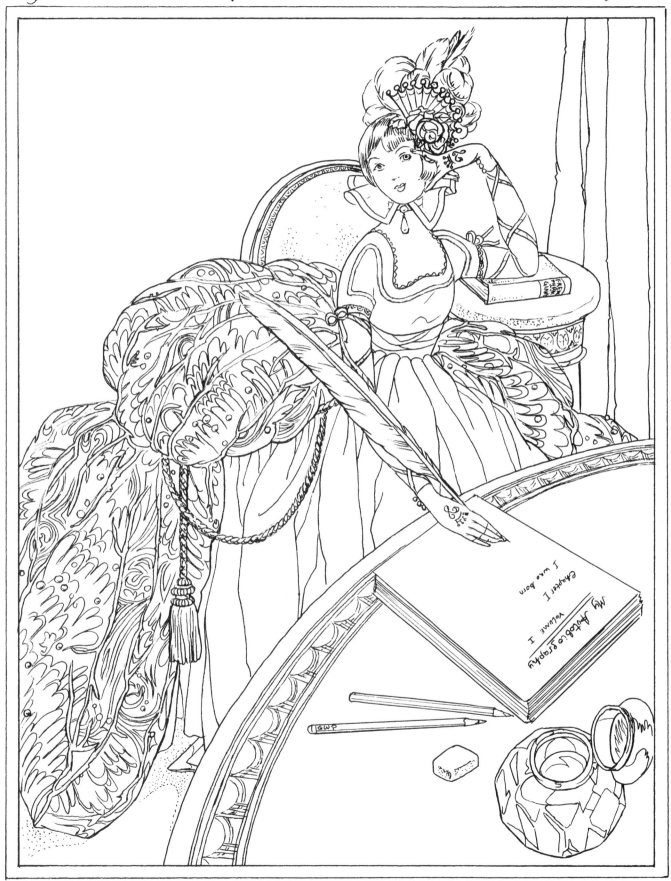

VOGUE

August 1·1921

Price 35 Cents

The Vogue Company
CONDÉ NAST Publisher

is for RAKE

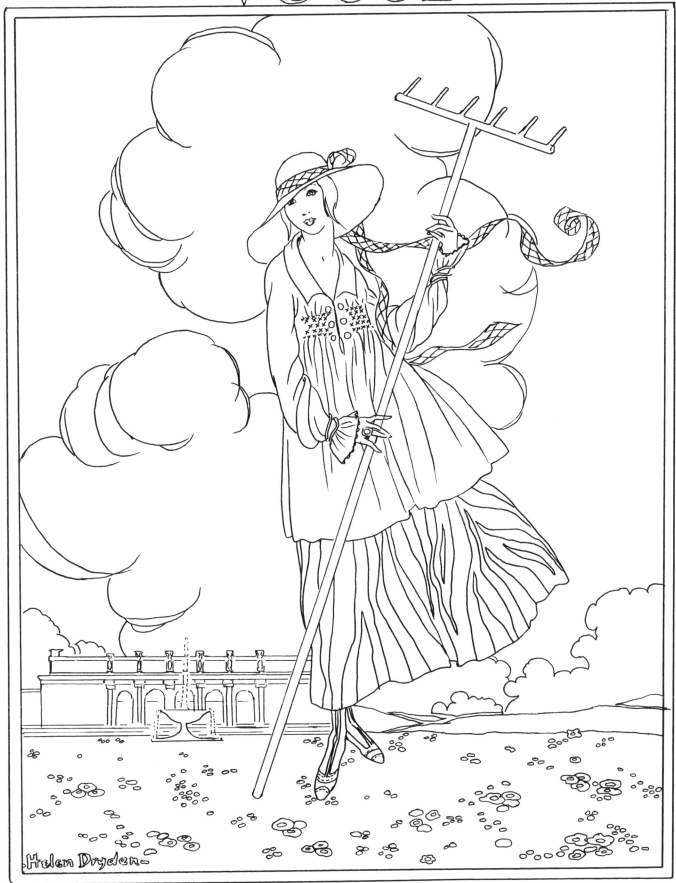

THE VOGUE COMPANY
CONDÉNAST — PUBLISHER

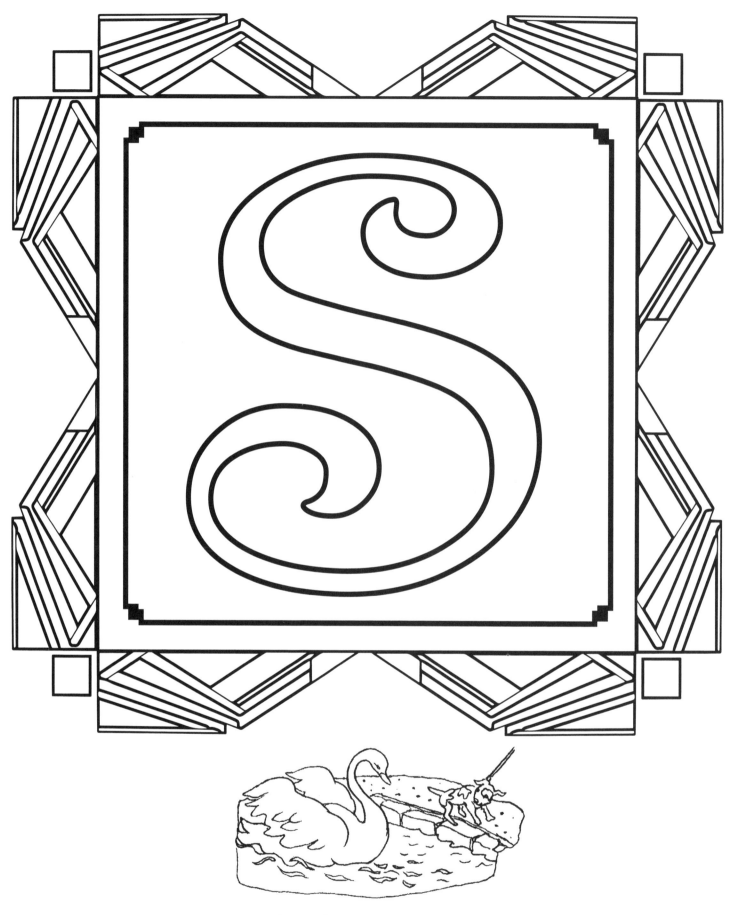

is for **SWAN**

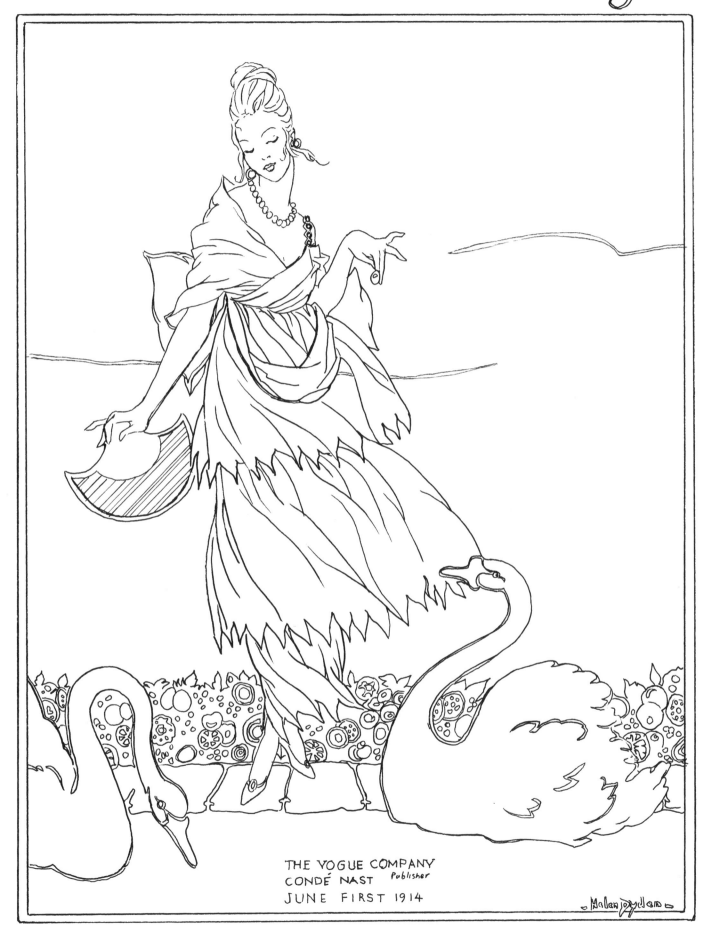

Summer Fashions number of Vogue

THE VOGUE COMPANY
CONDÉ NAST Publisher
JUNE FIRST 1914

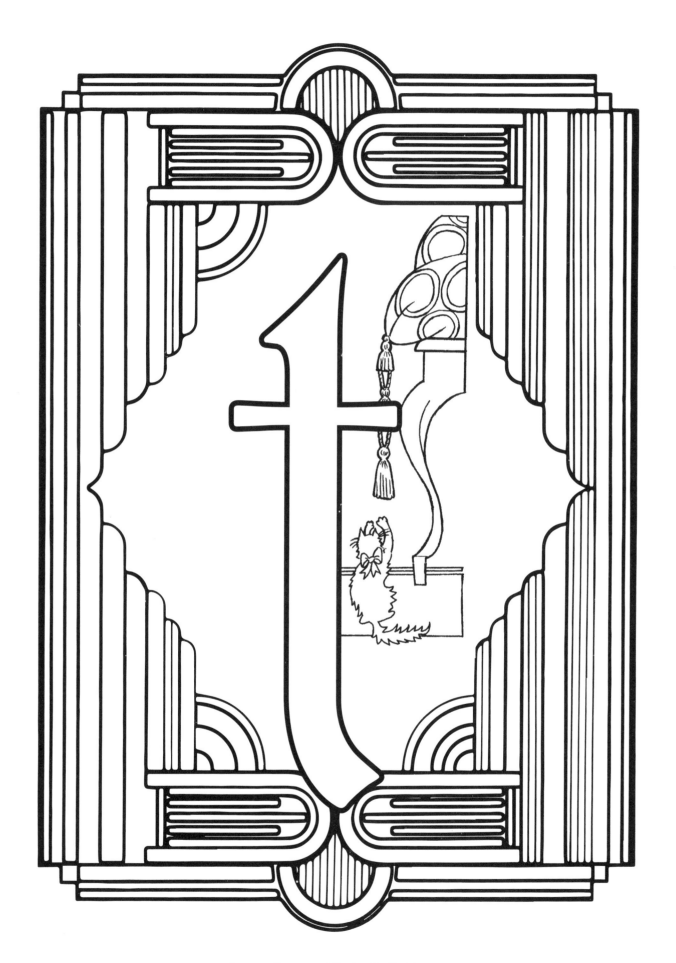

is for TASSEL

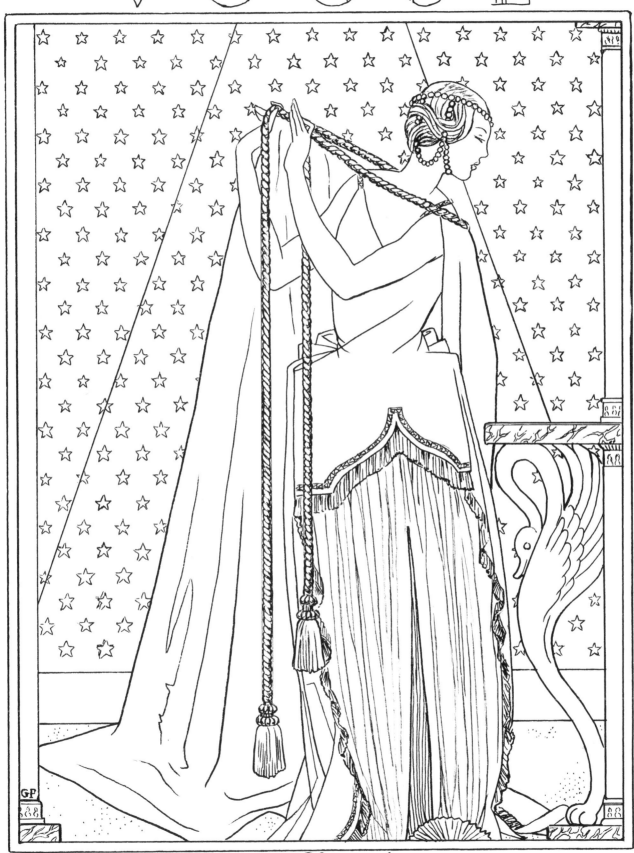

VOGUE

Summer Travel Number

The Condé Nast Publications Inc

June 15 · 1924

Price 35 Cents

is for UMBRELLA

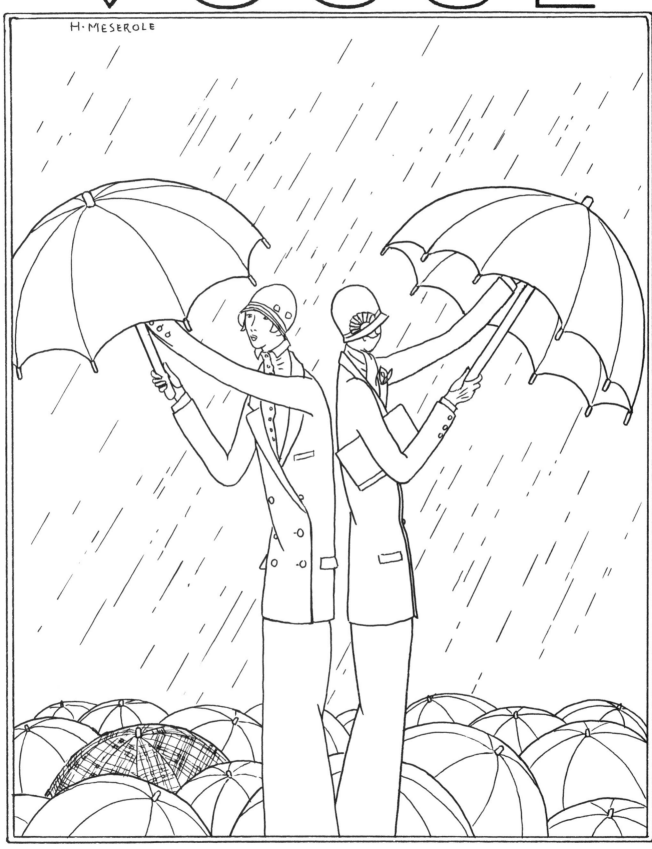

VOGUE

New York Fashions Number

The Condé Nast Publications Inc

May First-1924

Price 33 Cents

is for VIOLETS

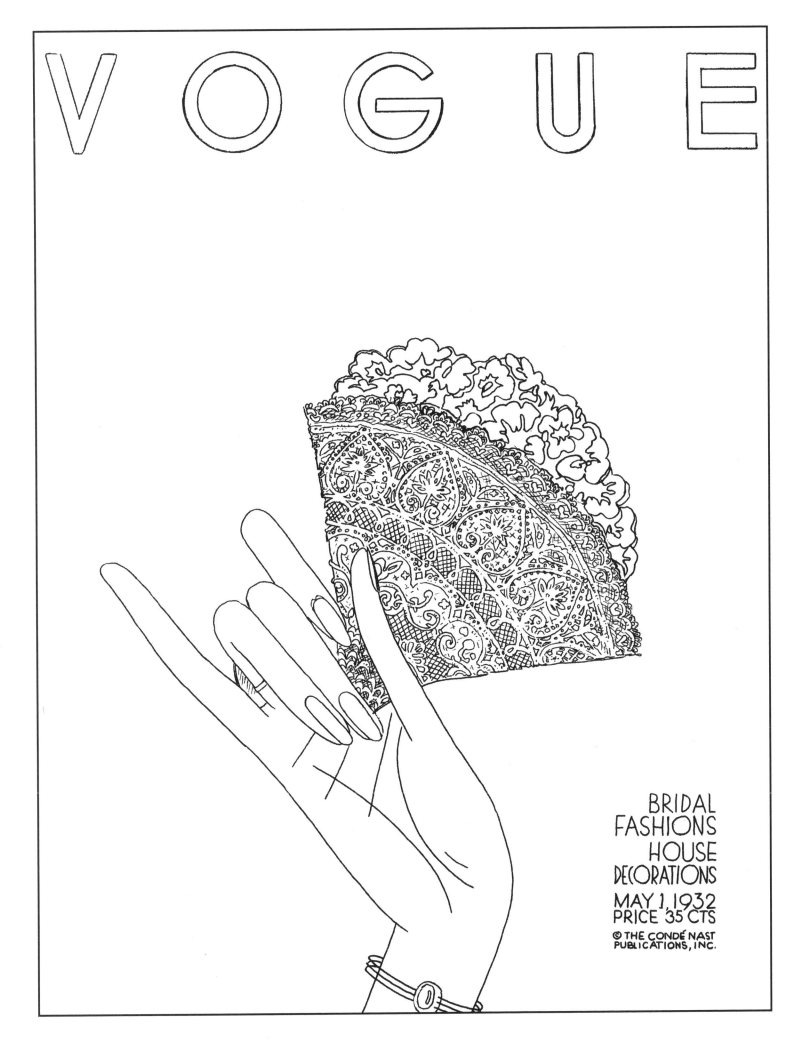

VOGUE

BRIDAL
FASHIONS
HOUSE
DECORATIONS

MAY 1, 1932
PRICE 35 CTS

© THE CONDÉ NAST
PUBLICATIONS, INC.

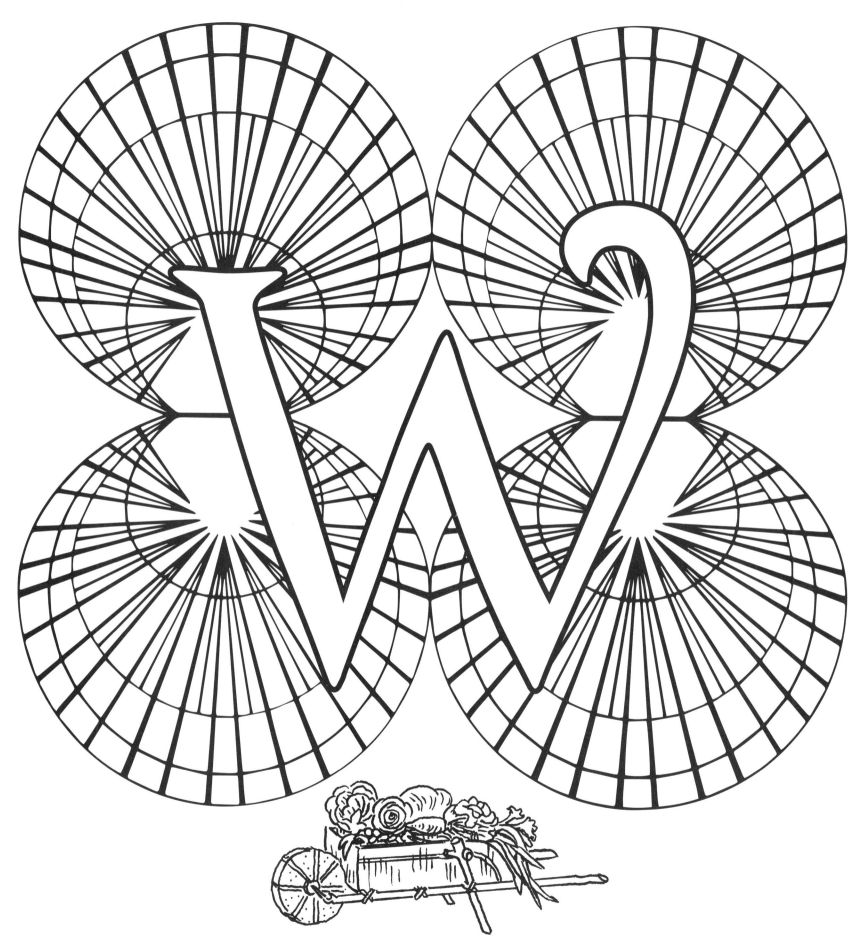

is for WHEELBARROW

VOGUE

JUNE 15, 1915

PRICE 25 CTS

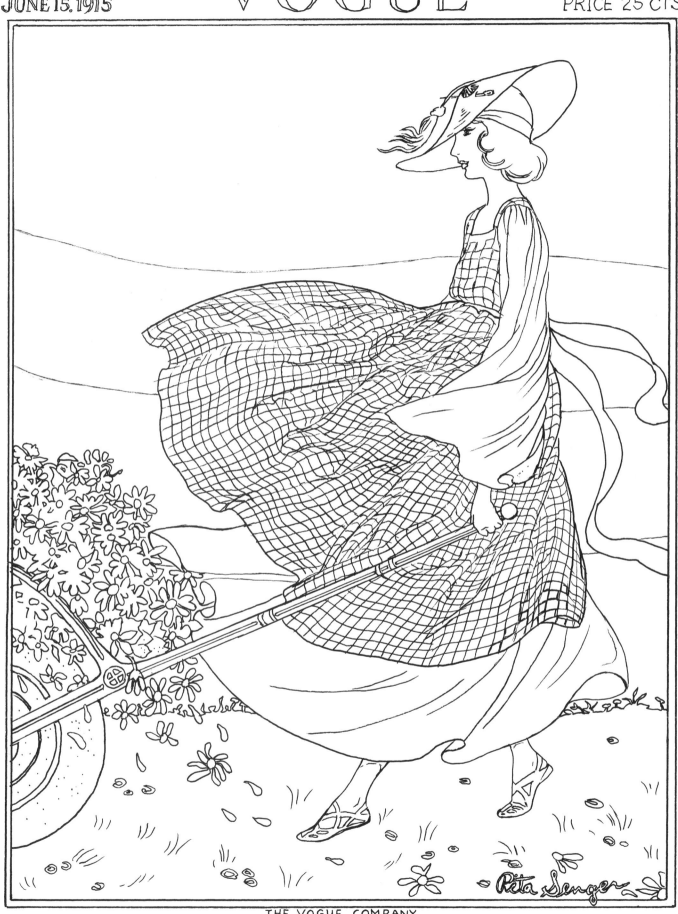

THE VOGUE COMPANY
CONDÉ NAST Publisher

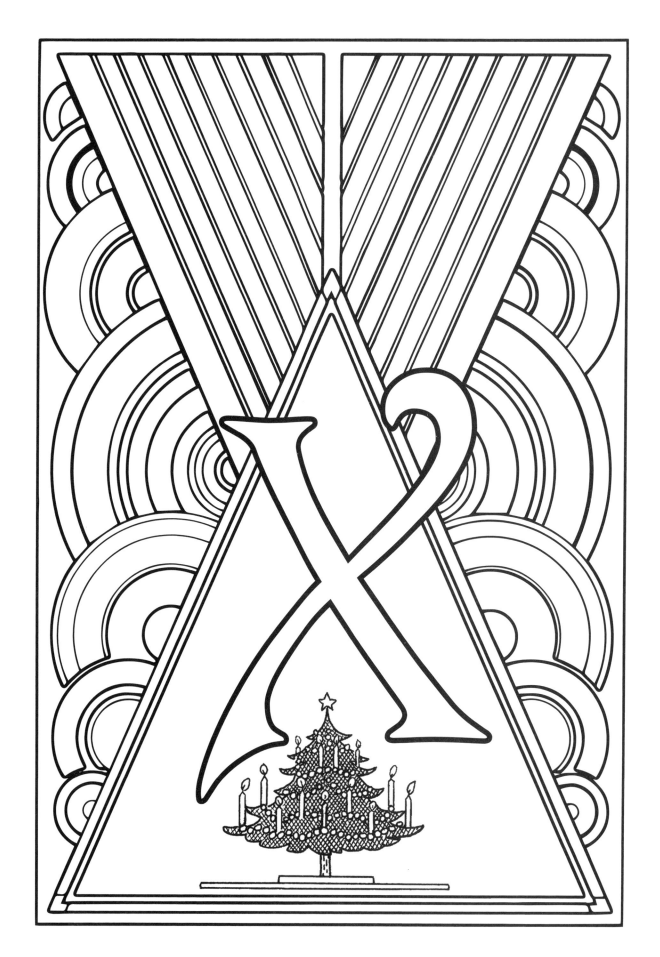

is for XMAS TREE

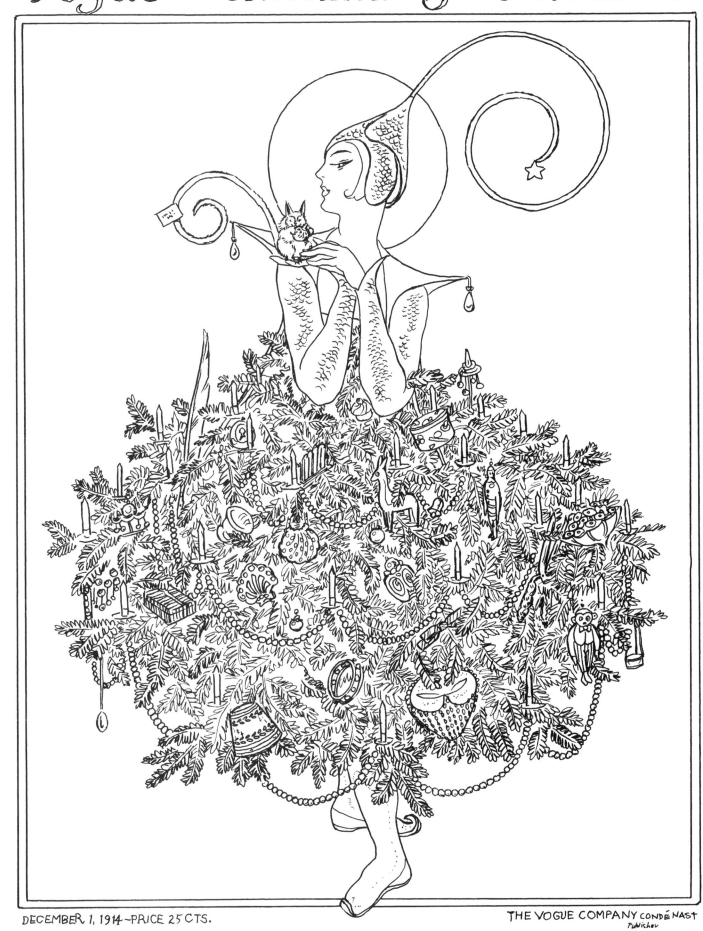

Vogue · Christmas Gifts number

THE VOGUE COMPANY CONDÉ NAST
Publisher

is for YARN

VOGUE

Christmas Gifts
Number

December 1·1922
Price 35 Cts.

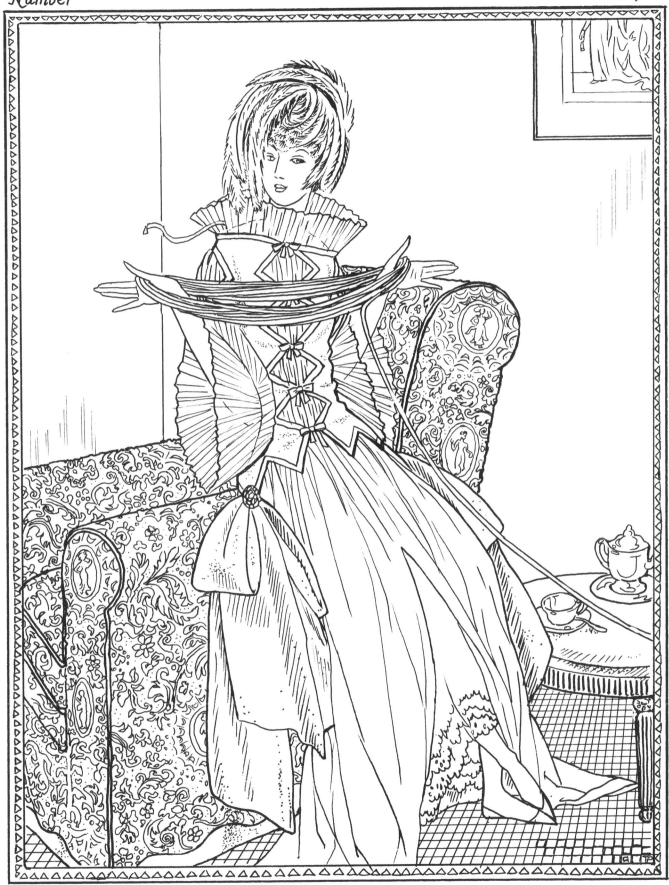

The Vogue Company
Condé Nast Publisher

is for ZEBRA

VOGUE

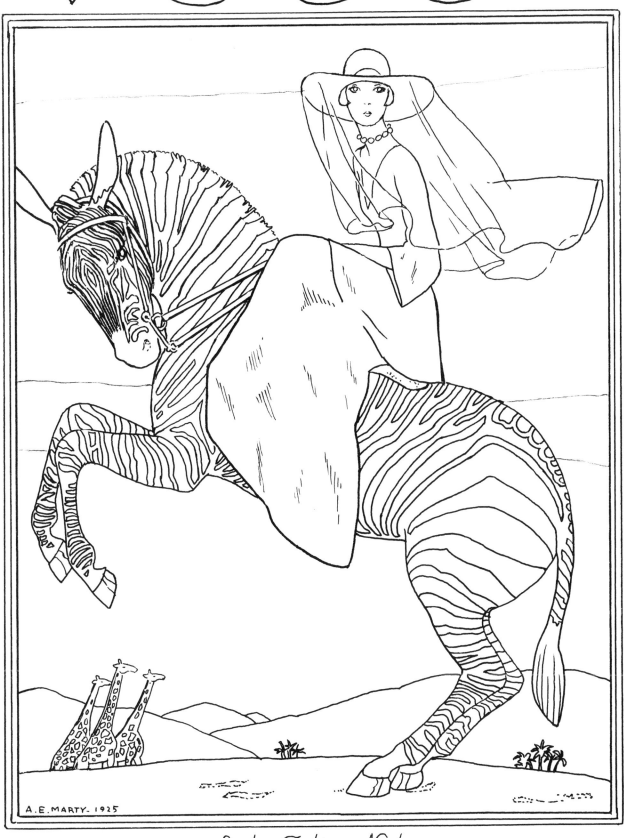

A.E. MARTY - 1925

January 15 1926

Southern Fashions Number

The Condé Nast Publications Inc.

Price 35 Cents

VOGUE COLORS FROM 1912 TO 1932

When the publisher Condé Nast bought *Vogue* in 1909, one of the first things he did was to move away from staid black-and-white covers in favor of color and action. Admiring the fashion reportage of the Parisian *Gazette du Bon Ton,* he hired several of its star illustrators, including Georges Lepape, André Marty, and Eduardo Benito, and began cultivating homegrown American talents such as Helen Dryden and George Wolfe Plank. This new wave of illustrations, featuring a well-dressed woman engaged in one activity or another, conveyed the latest fashion news and introduced hints of avant-garde art and design. Some of the illustrators, like Rita Senger, created a few covers and then faded from view; many others went on to have legendary careers. Executed in pen and watercolor, gouache and pencil, their work channels a riot of influences—Fauvism, the Ballets Russes, Aubrey Beardsley, Alphonse Mucha, Art Nouveau, Art Deco, Cubism, Modigliani, and the Japanese woodcut, to name but a few.

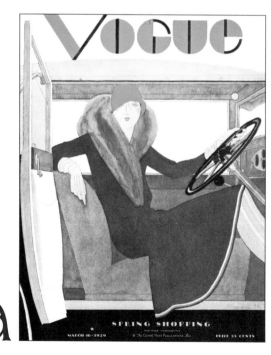

Pierre Mourgue, *March 16, 1929*

With one gloved hand casually resting on the wheel, Mourgue's driver conjures a generation embracing the speed of modern life. "Dashing young women prefer the independence of driving themselves," *Vogue* declared. The French illustrator was known for his spirited, sporty approach. His figure's sleek lines work well in an issue filled with Packard and Pierce-Arrow ads.

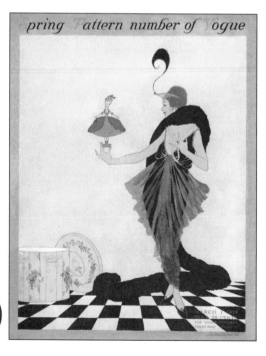

Helen Dryden, *March 1, 1914*

The Baltimore-born Dryden, eventually named the "highest-paid woman artist" in America, combined a delicacy of line and color with an eye for the vagaries of chic. This contemporary coquette, complete with trailing boa and dramatic headpiece, contemplates a Marie Antoinette–style doll. Elsie de Wolfe's redecoration of the Villa Trianon at Versailles is described in the same issue.

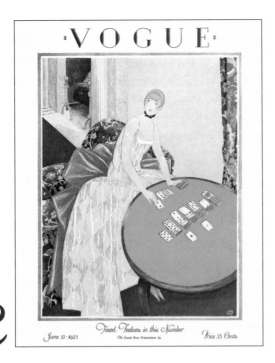

George Wolfe Plank, *June 15, 1925*

The Pennsylvania-born Plank, who moved to London in 1914, was known for fantastical images that transcended time and place. Here a more true-to-life cover girl wears a shimmering diamond-patterned evening dress in an elegant drawing room. With the requisite bob, ribbon choker, and dropped waist of the flapper, she plays solitaire, a nod to the new craze for cards, golf dice, chess, dominoes, checkers, and backgammon.

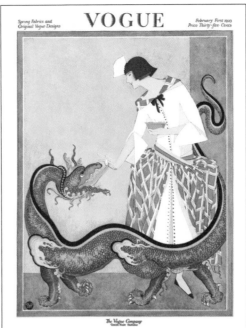

George Wolfe Plank, *February 1, 1923*

A woman feeds a sugar cube to a dragon on this playful cover, which refers to the trend of the moment: a passion for chinoiserie. Designers from Doeuillet to Vionnet embraced Far Eastern motifs in dragon-emblazoned wraps and dresses. The magazine reminded readers: "A familiar Chinese proverb says, 'Three-tenths of good looks are due to Nature, seven-tenths to dress.' "

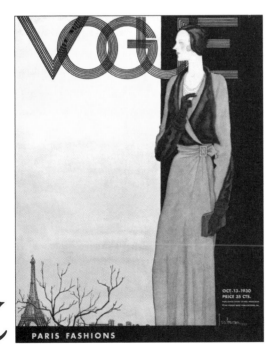

Georges Lepape, *October 13, 1930*

The Parisian illustrator first burst on the scene with his drawings for *Les choses de Paul Poiret* in 1911. His coolly posed subject looks to his city's most famous landmark. *Vogue* often reported on how quickly French fashions reached New York shops. "Almost any day, now," said one writer, "I expect to come across the Eiffel Tower itself."

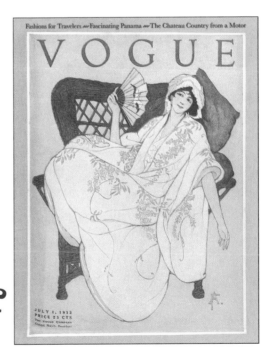

Arthur Finley, *July 1, 1912*

The New York–based Finley, who would leave illustration for business, had a sideline in magic, inventing the Tent Vanish card trick. He folds into this image of a woman lounging in a wicker chair the era's obsessions with "negligee attire" and Japonisme, reflected in the kimono line of her robe and the stork design on her fan.

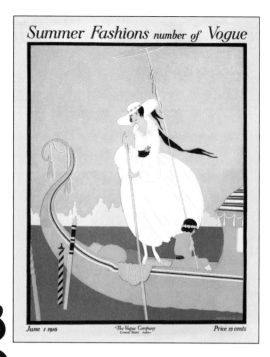

g

Helen Dryden, *June 1, 1916*

During the First World War, photographer Baron de Meyer wrote an ode to Venice, where one might spot "the Marchesa Casati . . . reclining in her gondola, wrapped in tiger skins and fondling her favorite leopard." Dryden's woman, in a billowing white dress, calls to mind its gondoliers, who wore white, while her ribbons evoke the wartime fad for trimmings.

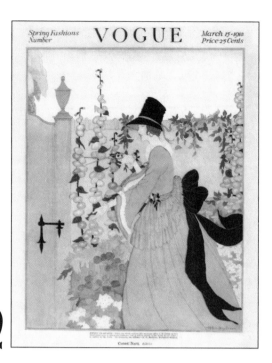

h

Helen Dryden, *March 15, 1918*

With vegetable plots becoming a national duty—"Are you a potatriot?" the magazine asked—Dryden's romantic figure, clipping morning glories in a walled garden, signals an older, more picturesque gardening style. A cover note stated that with a 1¢ stamp, the issue would "be placed in the hands of our soldiers or sailors at the front."

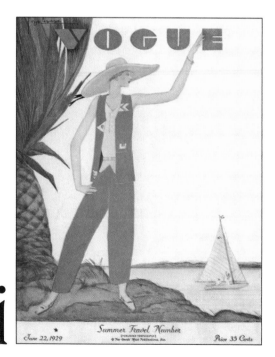

i

Georges Lepape, *June 22, 1929*

The Summer Travel Number covered the terrain from Bermuda to Budapest, and how to be "Chic en Route." Waving to a passing sailboat in breezy beach pajamas, Lepape's adventurer follows the new "rules for lounging." Art critic William Packer noted that this was the first time pants appeared as daytime wear on a *Vogue* cover.

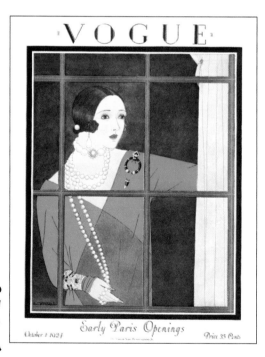

j

Harriet Meserole, *October 1, 1924*

One of *Vogue*'s youngest illustrators, the New York–based Meserole once stated, "I hate prettiness and ice cream." Her sharply drawn model of luxe looks out the window, demanding to be seen. Chanel began the craze for costume jewelry, which reached its height that year: "It is the jewellery, however, that gives the 1924 uniform its chief glamour."

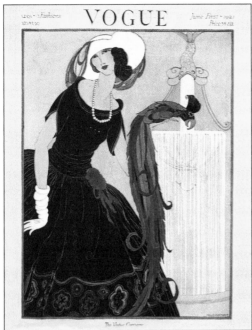

K

Helen Dryden, *June 1, 1921*

Keeping a bird, whether a Java sparrow or an English nightingale, was a favored 1920s pastime. This fanciful blue parrot perches on the hand of a young woman, her ribbon cockade echoing the bird's curling tail feathers. On her other hand she wears a white kid glove. Gloves were worn for every occasion, with the finest white kidskin reserved for evening.

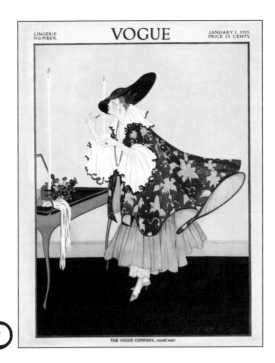

L

E.M.A. Steinmetz, *January 1, 1915*

The illustrator turned fashion designer E.M.A. Steinmetz shows a woman applying lipstick from a small metal cylinder, a contraption invented by Maurice Levy that year. Though controversial—MIND THE PAINT! the magazine warned—lipstick was gaining acceptance. This image decorated the walls of a brand-new Manhattan restaurant, the Café Moderne.

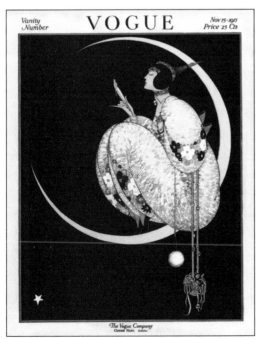

M

George Wolfe Plank, *November 15, 1917*

Suspended on a sliver of moon, Plank's Poiret-esque figure gazes into a hand mirror. Inside this Vanity Number, Dorothy Parker writes about slathering her face with the latest beauty potions. She confesses that had there been a fire, "I would rather have perished in the flames than let any fireman see me as I was."

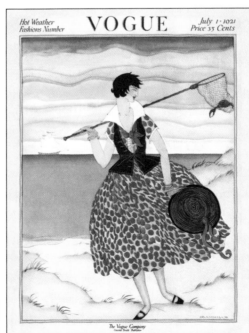

N

Helen Dryden, *July 1, 1921*

Dryden's carefree beauty takes to the beach in a full-skirted polka-dot dress and fitted vest, a handkerchief tied around her collar. (These were often worn to prevent sunburns.) Caught in her net is a crab, the astrological symbol for July and a delicacy of summer dinner-party menus, whether deviled, pickled, or potted.

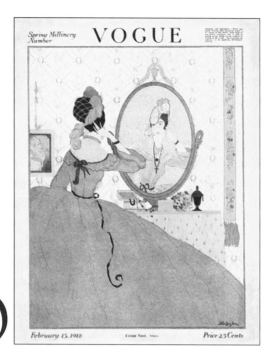

Helen Dryden, *February 15, 1918*

Dryden has fun with this portrait of a woman in a high-necked Edwardian tea gown at her dressing table. Despite the figure's conservative appearance, she is clearly very interested in the latest millinery trends from Paris, as revealed by her hat's cascade of ostrich feathers and patterned netting.

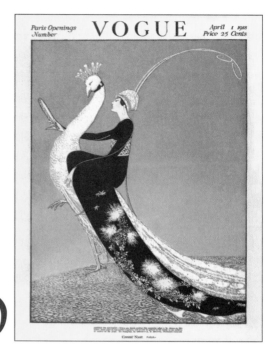

George Wolfe Plank, *April 1, 1918*

With a brilliant white peacock, Plank embarks on a fantasy inspired by the news from overseas: "Paris surrenders to the charm of the Orient," as fashion adopted lavish embroideries and the turban. At a benefit at the Waldorf-Astoria hotel in New York, guests reenacted this and other *Vogue* covers in photographs.

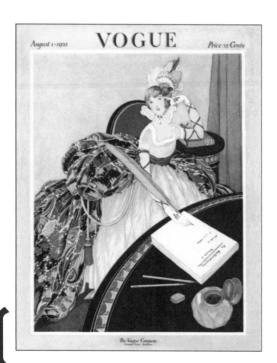

George Wolfe Plank, *August 1, 1921*

For an issue about "the perfectly appointed woman in the perfectly appointed home," Plank creates a cheeky image of an authoress in a Regency dress, struggling with a giant quill. Female autobiographies were taking hold: Margot Asquith, the former British prime minister's wife, had a best seller that year.

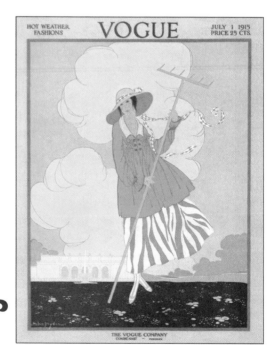

Helen Dryden, *July 1, 1915*

Standing on an estate lawn, Dryden's cover girl takes up the rake in the latest garden uniform: straw hat, striped skirt, and swingy smock. Backyard harvests would become a successful response to food shortages, though, *Vogue* noted, "one cannot pretend that cabbage is as beautiful as cosmos."

s

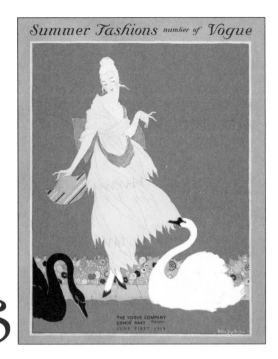

Helen Dryden, *June 1, 1914*

The last summer before the war, Dryden's figure,
with a "conical coiffure" that was the height
of style and a tiered skirt as "ruffled and puffed" as
the feathers beneath it, projects fashion's blithe mood.
Swans, like peacocks, were considered
ideal accessories for the well-manicured landscape.

t

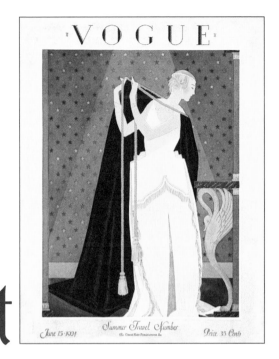

George Wolfe Plank, *June 15, 1924*

In a tribute to the new classicism, a woman in a pearl
headdress and fringed goddess gown removes
her tasseled cloak. Perhaps she's just returned from
the Lido Dancing Club, previewed in the issue.
Designers fell under the sway of French Directoire
elegance, which took its cues from ancient Greece.

u

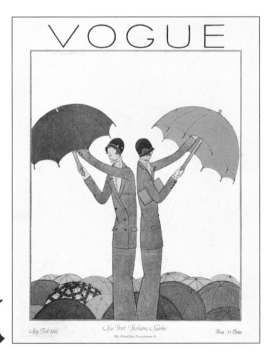

Harriet Meserole, *May 1, 1924*

"Who has sung of the surpassing charm of rainy days in
New York . . . ?" asked the poet Berenice Dewey in
Vogue in 1923. In Meserole's urban vision, two like-minded
women wearing the new tailored suit unfurl
umbrellas above a sea of open canopies. Slender and
boyish, they show off the popular garçonne look.

v

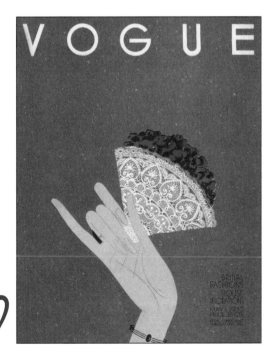

Eduardo Benito, *May 1, 1932*

The Spanish illustrator studied at the École des Beaux-Arts,
where he befriended the Cubists. Here, a floating
hand holding violets wrapped in lace conjures Modigliani.
Violets were recommended for bridesmaids'
bouquets, perfume, and even in "savoury salads for the
hostess," with mint, red sage, and marigolds.

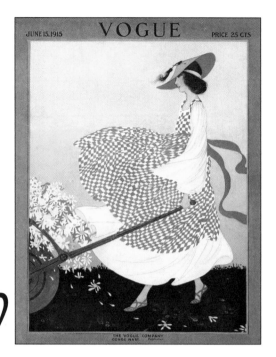

W

Rita Senger, *June 15, 1915*

With her jaunty, follow-me hat, Senger's figure indicates that the "Wheel of Fashion" was turning to simple pleasures. The apron tunic had quickly become a favorite, in gingham for day and in evening interpretations by French designers like Chéruit and Premet.

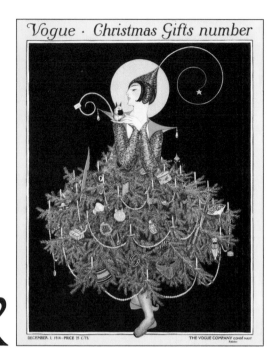

X

Unknown, *December 1, 1914*

A Plank-ish headpiece tops a woman decked out as a holiday tree, her branches hanging with pearls, candles, and presents. The tail of the small creature in her hand whimsically echoes the spiral of her cap. With pages of holiday gift suggestions ranging from cocktail trays to cravats, *Vogue* covered everyone on the list.

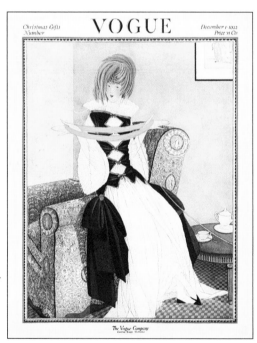

y

George Wolfe Plank, *December 1, 1922*

Since the war, "the call to knit" had been heard by all, including this stylish yarn winder, who wears a harlequin-inspired gown and ostrich-plumed headpiece. *Vogue* charted wool's course—"From Mary's Little Lamb to Mary's Little Frock"— as well as the allure of knitted accessories.

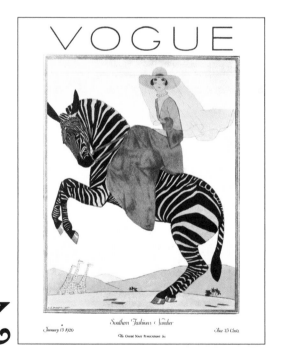

Z

André Marty, *January 15, 1926*

For an issue about "Adventures in Chic," Marty presented a woman in Victorian costume riding sidesaddle atop a zebra. So surprising was the image that the *New York Herald Tribune* devoted an entire editorial to it. But Marty knew that the zebra's "zig-zag" was catching on, whether on a patterned rug or a Chanel silk dress.